CW00376976

Guy Lafranchi & Daniel Egger

PRISONERS OF MUSEUM

RIEAeuropa Concept Series
Editor: Lebbeus Woods

Guy Lafranchi

c/o RIEA (Research Institute for
Experimental Architecture) Europa,
Bern, Switzerland

© 2001 Springer-Verlag/Wien and RIEAeuropa
Printed in Austria

Printing: A. Holzhausen Nfg., A-1070 Wien

Printed on acid-free and
chlorine-free bleached paper

SPIN: 10832255
CIP data applied for

ISBN 3-211-83644-6 Springer-Verlag
Wien New York

Graphic design:
H1reber, büro destruct, Bern, 2001

Photos:
Andreas Greber, Bern

Models by:
Luca Scarlatti, Hinterkappelen

Special mention:
Lebbeus Woods for his support on several fields
Chair design by "Camelle" (artist) and Daniel Egger

Introduction

The museum is a typology long overdue for change. New museums proliferate, with sometimes spectacular innovations in form, but their underlying conceptual structures remain much as they have been for the past two hundred years. They are Faustian incarnations, young bodies with old and weary souls. In Guy Lafranchi's view, the museum has become a prison, where critical ideas have been locked away from sight, without trial or appeal, by generations of directors, curators and scholars jealously guarding a canonized version of the evolution of art. As severe a charge as this is, it is only part of the story. The greater part, and by far the more serious, is the effect that the museum has on the production of art.

Contrary to its usual public posture, the museum is not a neutral, objective repository, but an active engine of art. The canon now enshrined in museums around the world is essentially ideological, promoting particular types of art and suppressing others. The museum is a frame placed around the very idea of art, which encourages productions that fit its contours. The rest is not merely excluded, exiled to nether regions where it might flourish, but are held prisoner by the hegemony of the canon. There are no more nether regions in the world of art. There is only an ever-widening, ever-extending global mainstream. There are no important museums of «alternative» art, or of «alternative» history, because there is no alternative to the mainstream, at least as long as the typology of the museum remains fixed, closed, and as ruthlessly 'universal' as it is today.

Most architects asked to design a mainstream museum would content themselves with resolving spatial and formal issues in their own terms. Lafranchi is an exception. His designs for a new typology reconfigure experiential space and historical time and the interactions between them, defining new and more paradoxical limits for art as product and idea. Considering that the museum has today become a (last?) refuge for the most innovative architecture – that which may itself be considered as art – I can think of few other tasks that are more difficult, more risky, or more urgent.

Lebbeus Woods
New York City
18 April 2000

- Declaration -

This manual is only given to persons who are connected with the prison's authority.
For security reasons, the Prisoners are not allowed to see this manual.
The Prisoners have individual cells.
The Prisoners are not allowed to communicate with each other.
For this Manual, each Prisoner had to collaborate with the following team.

Introduction to the Pamphlet: Lebbeus Woods, Architect, New York
Advocate of the prisoners: Konrad Tobler (K.T.), Journalist, Bern, Switzerland
Graphic: Hlreber, Büro Destruct, Bern, Switzerland
Photographer: Andy Greber, Bern, Switzerland
Modelbuilder: Luca Scarlatti, Hinterkappelen, Bern, Switzerland
Translation work: Checkmate Prince, Bern, Switzerland

Imprisonment prevents the emergence of a new type of museum.

The prison's authority

Contents

CN°4P38

CN°5P48

CN°6P58

CN°7P08

PRISONER: TIME FREQUENCY, EPOCH FREQUENCY
AGE: INDETERMINATE
SEX: YES
CRIME: JEOPARDISING THE COMMONLY
ACCEPTED VIEW OF HISTORY THROUGH
UNPREDICTABLE OVERLAYS
PREVIOUS CONVICTIONS: NONE

Der Alltag wird in das Museum integriert, entgegen dem klassischen Muster von Museum. Das „Echtzeitgerüst" lebt von permanent wechselnden Auseinandersetzungen. Diese sind nur möglich, wenn Räume dafür integriert sind. Museum als Ort des kontinuierlichen Austauschs Zeitfrequenz (regelmässige Skala) und Epochenfrequenz (unregelmässig, je nach Intensität) werden einander gegenübergestellt. Ihre Ueberlagerung bildet das statische Grundgerüst des „Nervenstrangs", welcher u.a folgende Aufgaben übernimmt; Träger von Zirkulation, Interaktion der Verschiedenen medialen Ebenen, Auditorien, Einzelarbeitsplätze, Projektion. Er bildet die Infrastrukturlinie.

In der Geschichte sind neue kreative Prozesse, welche u.a auch zu neuen Epochen geführt haben, oftmals aus Katastrophen ,politischem Desaster und anderen Krisen hervorgegangen. In der Physik werden diese dynamischen Zustände auch als Phasenübergänge bezeich Es beschreibt einen Zustand hoher Komplexität (order-COMPLEXITY-chaos). Diese Momente der Geschichte definieren auf der Epochenskala die räumliche Konnfrontation mit dem „Nervenstrang". Diese andockenden Strukturen bilden untereinande zusammen mit dem Nervenstrang Zwischenräume, die Epochenräume..

The people who are always in the right are the people who lay down the law. The people who are always in the wrong are the people who ask questions. For that very reason, it has to be said that 1P04 is right on all counts. For time is a river and as such is never still. Only as a unit of measurement is time continuous. The pre Socratic Greek Heraclitus recognised the relativity of time, because historical time is not time in the sense defined by Classical, pre-Einstein science: "We all enter the same river and yet it is not the same river. We are it and we are not it."

In truth, time does not move as a continuum but rather as a discontinuum: between the overlaps, the references to what will be or has been, or, to put it differently, between the simultaneities of the other, the traces of memory that have not been obliterated, in which past and present are not mutually exclusive.

Architecture and the traditional museum have one thing in common: the static and linear quality of their concept of time. Walk around the Louvre, walk through the multitude of galleries, and you will see how time is strung out like the beads of a rosary. And yet all these epochs and galleries were in fact steeped in each other, in the way that art theory, breaking away from the historical perspective of the 19th century, at the latest since Aby Warburg, has imagined it.

E_{∂_9} $F_{\partial_{10}}$ $E_{\partial_{11}}$. . EPOCHEN RYTHMUS

that is still not being expressed in the architecture of museums. They too nurture the static, linear treatment of ... Walter Benjamin's concept of discontinuous time, which he described as "the leap of a tiger into the past," where ... flash the now appears in the past and, vice-versa, where the past can be recognised in its presence in the now.

... rchitecture which sees time as a constantly changing axis into which space intervenes and breaks the continuity, ... rchitecture through which static space sets time in motion, would do justice to the historical and philosophical ... strate of a museum – and would at the same time clearly illustrate that even the concept of time is subject to ... , and therefore has to be a part of that which the museum as an institution must reflect. In that way, time itself ... ld become an object in the museum. Go into the new museum and you will see that you will not stand lost and ... out direction but will be moved. (K.T.)

T_{∂_5} T_{∂_6}

F_{∂_5} T_{∂_6}

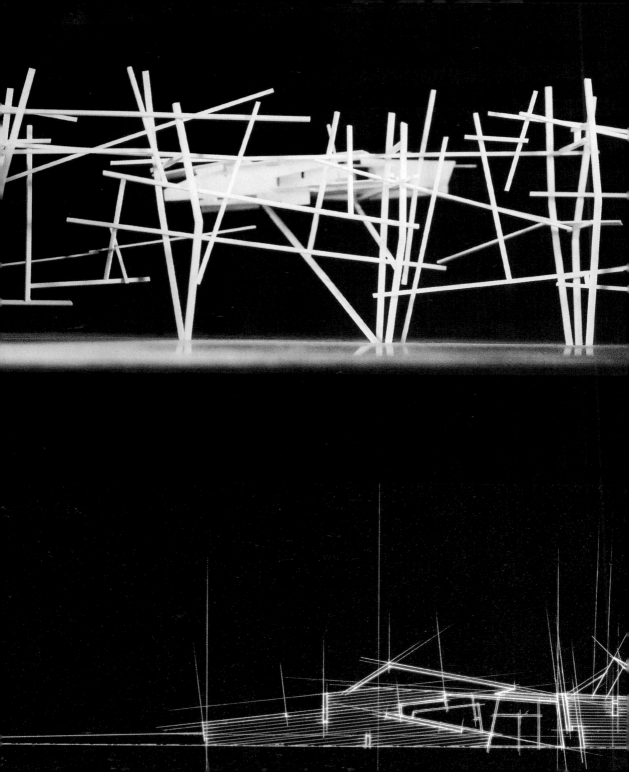

story... An excess of history has attacked life's formative power; it no longer knows how to
the past as a source of nourishing food."
edrich Nietzsche, "Vom Nutzen und Nachteil der Geschichte für das Leben," (On the advantage
disadvantage of history for life) Diogenes Verlag, p.103
e traditional task of a museum is still bound by the old definition of collecting, preser-
g, researching and presenting. But the museum of the future is a place of many and varied
ns of communication."
eums ask questions, questions that are triggered by the present but are firmly rooted in the
. I do not exhibit the past, but place historical developments in a context and make it
sible to process the problems that emerge. By contrast, traditional museums do not ask que-
ons, they merely give answers. The contemporary museum asks questions without answering them.
is an institution for communication.
e spaces that are still being created remain trapped in the spirit of the 19th century, or
20th century at best. The concept of the museum has not been revised, either in architectu-
or any other terms. There are some superb architectural concepts but barely a single museum
cept that could be called superb."
ter Bogner, museum consultant, newspaper interview entitled "Museum of the future" Berner
tung, 19.2.2000
ted: Museum of Art History. We are looking for a scheme which makes it possible to "walk
ough" the history of art at a height of 300metres, to re-experience the different epochs in
ir context and inhale history.
"Real Time Scaffold" lives from permanently changing confrontations. This is only possible
appropriate spaces have been integrated into the building. The museum as a place of conti-
l exchange.
e frequency (regular scale) and epoch frequency (irregular, depending on the intensity) are
ught face to face. Where they overlap is in the static framework which is the "nerve cord."
functions include: being a vehicle for circulation, a place for interaction between the
ferent media levels, auditoria, individual workstations, projection.
forms the infrastructure line.
oughout history, creative processes which have led to new epochs have often emerged from
astrophes, political disasters and other crises. In physics these dynamic states are also
wn as phase transitions.
s describes a state of high complexity (order-COMPLEXITY-chaos). These moments in history
k on the epoch scale the spatial confrontation with the "nerve cord". Together with the
ve cord, these docking structures form intermediary spaces, the epoch spaces...
wounds of time are given material form and captured in space.
ganic Space-Time versus Mechanical Space-Time; Mechanical space and time are both linear,
ogeneous, separate and local. In other words, both are infinitely divisible, and every bit
space and time is the same as every other bit. It is the space-time of frozen instantaneity
tracted from the fullness of real process, rather like a still frame taken from a bad movie
m, which is itself a flat simulation of life. The passage of time is an accident, having no
nection with the change in the configuration of solid matter located in space. And yet it
in overcoming the imposed illusion of the separateness of things that the artist-scientist
ers into the realm of creativity and real understanding, which is the realm of organic
ce-time."
k; Spirals, Quaderns-series, p.150 "The new age of the organicism" by Mae-Wam Ho.

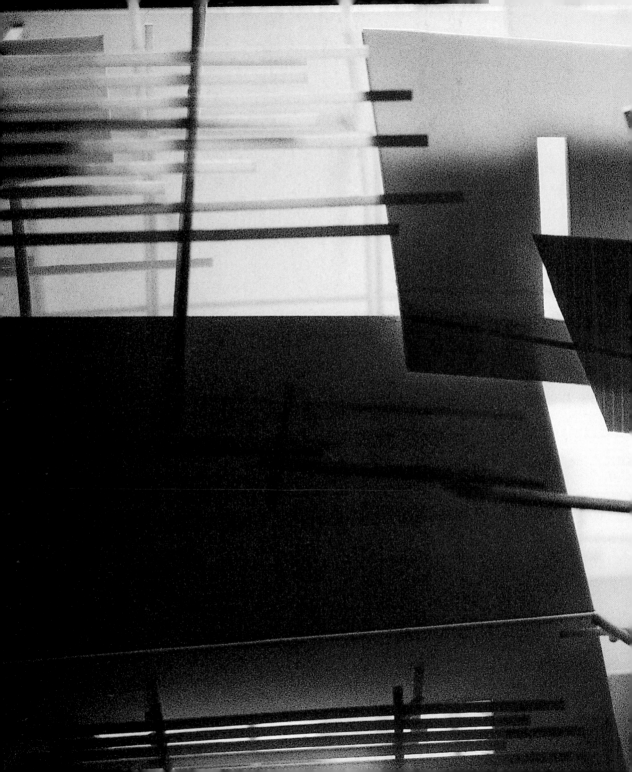

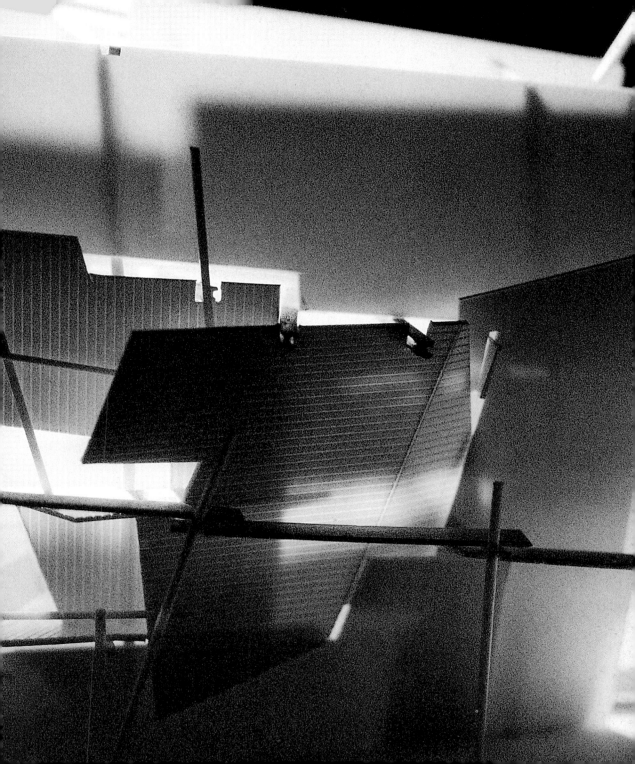

CN°2P18

PRISONER: MEASURING CULTURE, WRITING A CRITIQUE OF DATA
AGE: UNKNOWN
SEX: YES
CRIME: UNDERMINING THE STRICT HIERARCHICAL
ORDER IN INFORMATION TRANSFER
PREVIOUS CONVICTIONS: NONE

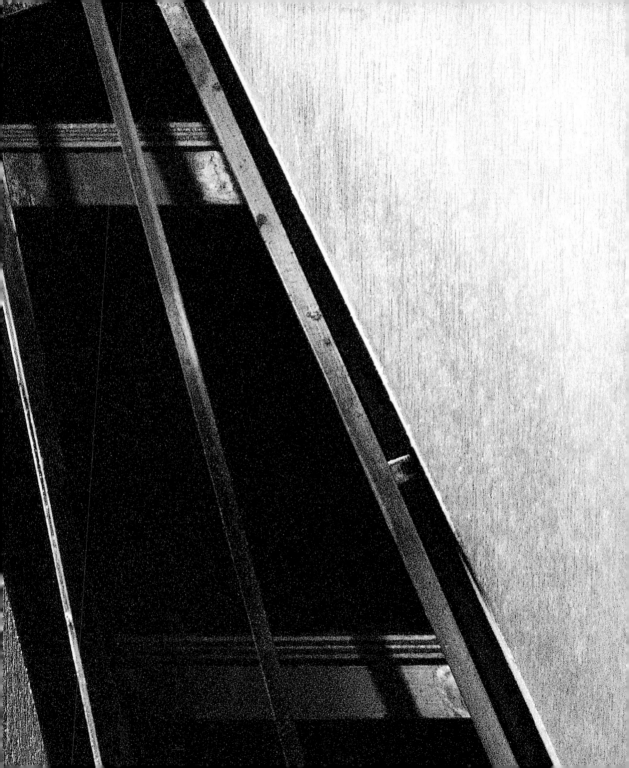

Das additive Grundmuster der aneinandergehängten Epochen wird mit unserer Zeit konfrontiert, welche anderen Phänomenen unterliegt: dezentral, Netzwerk, fraktal, übergreifend, Transformation

Zunehmende gesellschaftliche KOMPLEXITÄT bei gleichzeitiger DEZENTRALISIERUNG hat ein neues Organisationsprinzip der VERNETZUNG etabliert, entgegen der traditionellen Methode einer Komplexitätsreduktion durch Zentralisierung und Hierarchiebildung. Orientierung von genormter Massenproduktion hin zu individualisierter just-in-time Produktion. Interaktive Medien unterlaufen die grundlegenden Funktionen einer gerichteten Kommunikation über die Massenmedien. Das Prinzip der INTERAKTIVITÄT stimuliert die individuelle Einmischung und erzeugt komplexere Kommunikationsmuster, als das Modell der Nachrichten- bzw. Informationsübertragung sie vorsieht. Interaktivität baut auf Digitalisierung, und diese erlaubt die relationale Verknüpfung verschiedenster Informationsmodule, wobei die Inhalte selbst hybridisiert werden. Das heisst es ist nebensächlich, welchem ursprünglichen Zweck ein Medium gewidmet war; Bild- und Tonaufzeichnungen werden ebenso problemlos in den digitalen Speichermodus integriert wie Textverarbeitung

Mögliche Reaktion in der Philosophie; sie könnte so aussehen, dass nach der Vernunftkritik des achtzehnten und der anschliessenden Sprach- und Kulturkritik des neunzehnten und zwanzigsten Jahrhunderts nun eine "DATENKRITIK" geleistet wird, welche die Bedingungen der Möglichkeit einer Informationsgesellschaft kritisch reflektiert.

Datenkritik ist ein kritisches Unternehmen, welches auf der Grundeinsicht beruht, dass Medien keine Informationen *über* die Welt *vermitteln*, dass ihre Inhalte also nicht als Zeichen von Objekten anzusehen sind, sondern eigene Zeichensysteme errichten

Those who negate unambiguities are always suspect. That is why 2P24 fell under suspicion. Complexity is always see as the start of chaos. And yet complexity is merely a higher degree of order, a system of more complex structures in which hierarchies appear to be flatter, more intertwined. That is the beginning of any dialectic process...

Look at history therefore as a rhizomic structure, in which top and bottom, front and back, before and after, are tangled up in one another. The centre – which is seen as the breaks between the epochs – is then everywhere, is constant re-forming. For the centre, the break, has always appeared before the break: the Renaissance began in the Islamic worl it did not only begin in 1500; Raymundus Lullus and Leibniz started what we now have in front of us in the form of the laptop, with which, now, at this very moment, these lines about time and museum time are being written.

Now go into an exhibition about the Renaissance. It is Venice in the autumn of 1999: the time of the Renaissance is no longer unambiguous, the South learnt a lot more from the North than we had previously imagined, the rational order of that time has been given a pretty hefty shake-up by Bosch's fantasies.

Now join with 2P24 in shaking up architecture. See it as dialectic, even dissolving dialectics: rhizomic, multi-layered, many stages, tangled up. And then it begins not with something but with nothing or, to be more precise, with the moment of Inter-Esse: with everything between the two. That is how it makes space (for itself). It is then no longer based on the hierarchical model of a palace, as is clearly the case in traditional museums, it is based on twists and turns, as mimetically described by Kafka in his texts. Instead of Versailles, the bazaar is created, the old town in Zanzibar. First of all confusion reigns, then possibility and probably. But then emerges the brightest awareness of the uncertainties. Remain pretty suspect. Free yourself from the fear of being suspect. (K.T.)

...F.hang der Epochen dargestellt worden. Das additive
...it konfrontiert, welche entgegengesetzten Phänomenen unter-
...[→] ein hierarchisch luziveres Gebilde wird auf
...7,35. A X.7 B] "Die Epochenabfolge ≠ spontiges
Die Auseinandersetzung beinhaltet eine Konfrontation,
[crisis] neue Konzepte in Kunst und Architektur
...Katastrophen, politischem desaster etc. Diese
'Spontaneität', Risiko, Experiment. Begriffe, welche
...nehmung "Störungen" als voneinander elemente -
...nicht als separate) Spur (→ein stolant integriert

angeordnet sein ! Bretter
Objekt od. Architektur -
work - in progress - Arbeit .
Ein bezogues Theenun [+ 2.B x_2]
[Dialog][F R A G M E N T E] durch .
Epochenfrequenz .
Zeitfrequenz des Rhino-

bahn - Informationsträger - Kommunikation . Projektion -
der Vernetzung
Das Rückennoth
Techno Rückgrat

...der Vernetzung ↗ Rückennoth verbinden und -
...übereinander - puls der Zeit - "no prep - show - "aus 7.

"Measure just once the height of your knowledge by the depth of your skill"
Friedrich Nietzsche, "Vom Nutzen und Nachteil der Geschichte für das Leben," (On the advanta
and disadvantage of history for life), Diogenes Verlag p.84.
The epoch scale of art history: the individual epochs and the transitions to the next epoch
published in an idealised form in all the art history books. But this is nothing but a decept
abstraction. The transitions, I call them disturbances, between the epochs are
marked on the time axis as points – if they are mentioned at all. In truth, both the epochs
the disturbances are of different intensities from country to country, region to region.
Sometimes they do not exist at all. The epochs overlap, intersect each other, do not touch e
other, flow into one another in a continuum. This questions quite fundamentally the additive
approach by which they are strung together.
Our idea is to integrate into the museum concept the site-specific intensity difference of t
epochs and the intermediary space.
The basic additive pattern of epochs strung together will be confronted by our time which is
subject to other phenomena: decentralised, networked, fractal, overarching, transformation

creasing social COMPLEXITY combined with simultaneous DECENTRALISATION has established a new
ganisational principle of NETWORKING, in contrast to the traditional method of reducing com-
exity by centralisation and the creation of hierarchies... a change in orientation from stan-
rdised mass production to individualised just-in-time production... Interactive media undermi-
 the basic functions of precisely targeted communication via the mass media. The principle of
TERACTIVITY stimulates individual involvement and generates more complex
tterns of communication than the model of news or information transmission has foreseen.
teractivity is based on digitalisation and this permits a relational connection between the
st varied information modules, with the content becoming hybridised. In other words, the ori-
nal purpose of a medium is completely incidental; recorded images or sound can be integrated
o a digital storage medium just as easily as word processing files.
possible reaction from philosophy; it could be that, after the critique of reason of the
ghteenth century, which was followed by the critique of language and culture of the nine-
enth and twentieth centuries, there will now be a "CRITIQUE OF DATA" which will reflect cri-
ally on the conditions of the possibilities the information society is offering us.
itique of data is a probing undertaking which is based on the fundamental insight that media
 not convey information about the world, that their content is not to be seen as symbols
presenting objects but that they set up autonomous systems of symbols of their own.
l-Time-Grid

 second = 9192631770 oscillations of a caesium atom)
asurement; A caesium clock has, since 1967, redefined the basic measure of the second as the
ration of 9192631770 oscillations of a caesium atom. Since 1983 the meter has been redefined
 the distance that light travels through in a vacuum, i.e. the distance covered in
99792458 of a second.

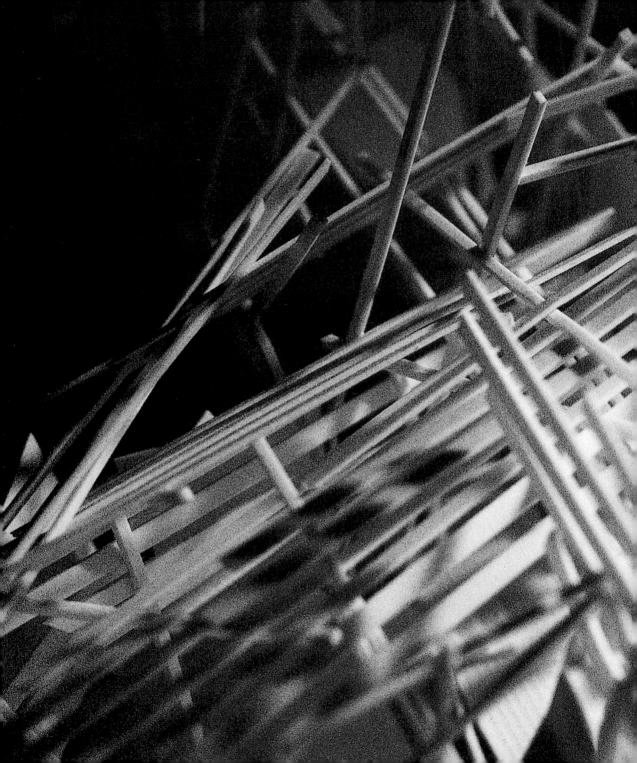

CN°3P28

PRISONER: ART STUDENT, HOMELESS PERSON
AGE: UNKNOWN
SEX: YES
CRIME: DISTURBANCE OF THE ESTABLISHED,
CONTROLLED TEACHING OF HISTORY
PREVIOUS CONVICTIONS: NONE

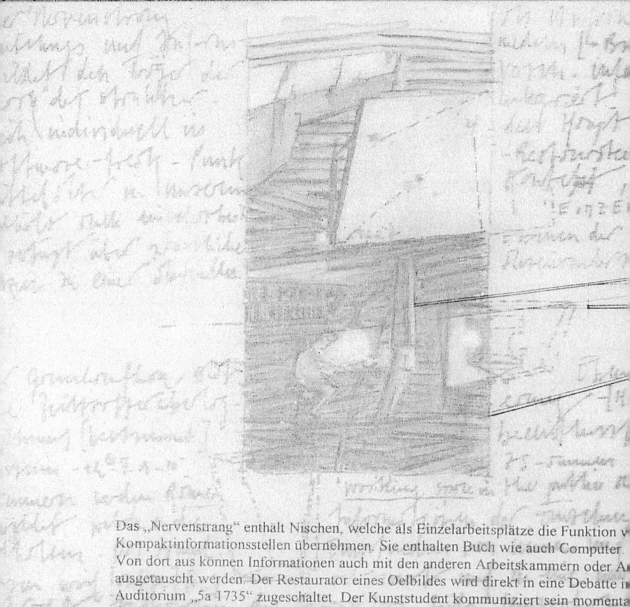

Das „Nervenstrang" enthält Nischen, welche als Einzelarbeitsplätze die Funktion v
Kompaktinformationsstellen übernehmen. Sie enthalten Buch wie auch Computer.
Von dort aus können Informationen auch mit den anderen Arbeitskammern oder A
ausgetauscht werden. Der Restaurator eines Oelbildes wird direkt in eine Debatte i
Auditorium „5a 1735" zugeschaltet. Der Kunststudent kommuniziert sein momenta
der Arbeit mit dem Museumbesucher. Grenzen von Ausgestelltem und Betrachter g
in ein dynamisches Gefüge individueller Betrachtungen.
Die neuen Medien oder der Uebergang vom typographischen zum elektronischen P
Datenverarbeitung schafft eine neue Medienwirklichkeit, die fünf Jahrhunderte der
Mechanisierung ebenso hinter sich lässt, wie die Renaissance zwei Jahrtausende Al
und Manuskriptkultur durch den Mechanismus der Wiederholung und Quantifizier
abgelöst hat.

NERVENSTÄRKE

Being a spanner, instead of oil, in the works: that is what 3P34 stands accused of. Stop the old accusations. "Off with him to Moscow" was the cry in the old days of the Cold War. Admittedly, the demand that everyday life should be integrated into museums was first voiced in those olden days before 1968 and put in writing too. "The museum as a prison" was the title of a pamphlet published at the time which attacked the bourgeois order of museums. So-called threshold anxiety was what had to be overcome, it was said then in those days of Utopian revolution. That has long since been overcome. But it has created nothing other than the law of capital accumulation, which the museums now obey. Museums in the U.S.A. have managed to attract the masses and thus integrate everyday life into the museum.

A hamburger in front of the Mona Lisa or a Mona Lisa hamburger – why not? It does not make the Mona Lisa any more beautiful. Nor any the less enigmatic. Reverence is not what is required (although places of tranquillity are just as necessary as ever: it is the unredeemed promise of the White Cube, which still wants to be understood as a Black Box. In other words, the idea of integrating everyday life into the museum is merely the implementation of what has been practised in art since the beginning of the last century: there could be no Duchamp urinal without an ordinary urinal, no crazy work of art without everyday craziness, no Warhol without Campbell's cans. For art is the critical encounter with the everyday and ordinary – even if part of that everyday life is the adoration of the Assumption or the rapt contemplation of a Rothko painting.

heaven's sake, no-one is going to question the institution of the museum per se with the simplistic statement that transitions between everyday life and reflection upon it are fluid, have to be fluid. The museum is simply another e, a new context. And therefore it is a place of what is, of necessity, other. So no more Utopian clean sweeps, no la rasa, God forbid, for the reactionary demand of the Futurists to get rid of museums – "We want to destroy eums, libraries and academies of all kinds" (Marinetti) - itself belongs to the layers that have been stowed away e depositories of our museums.

like 3P34, we admit: the dynamic nature of the concept of time demands a dynamic architecture both in formal spatial terms. This, of course, refers back to the legacy – still unclaimed – bequeathed by the Soviet Constructivists. an architecture that is aware of constant radical change, but without that Utopian overlay peculiar to the Modern ement. It is an architecture which inquires after the conditions under which dynamic architecture is possible, but ch refrains from formulating them into a dogma. Now go, as cautiously as a tightrope walker, as sure and as supple contortionist, through the new museum. And sit yourself down, make yourself at home, in front of the latest video allation: simply curious. (K.T.)

"If the value of a drama lay solely in the final and main ideas, the drama itself would take
extremely long, tortuous and wearisome path to its goal; and so I hope that history does not
see its significance in general ideas, in a kind of blossoming and fruition, but that its va
lies in circumscribing a well-known, perhaps ordinary theme, an everyday tune, elevating it,
raising it to the level of an all-embracing symbol and thus intimating in the original theme
entire world of profundity, power and beauty."
Friedrich Nietzsche, "Vom Nutzen und Nachteil der Geschichte für das Leben," (On the advantag
and disadvantage of history for life), Diogenes Verlag, p.59

In contrast to the classical museum model, everyday life will be integrated into the museum.
The "nerve cord" contains niches which are individual workstations and take on the function
compact information points. They contain both books and computers. From there information can
exchanged with other carrels or auditoriums. The restorer of an oil painting will have a dir
link into a debate in auditorium 5a 1735. The art student tells the museum visitor about the
progress of his work. How does a homeless person influence the debate in the structure? Or w
about a passer-by who just wants to pay a quick visit to the toilet?

Boundaries between exhibits and visitor flow into a dynamic structure of individual temporary
observations. The new media, or the transition from the typographic to the electronic princi
of data processing, creates a new media reality which leaves behind it five centuries of mec
nisation, just as the Renaissance replaced two millennia of alphabet and manuscript culture w
it embraced the mechanisms of duplication and quantification.

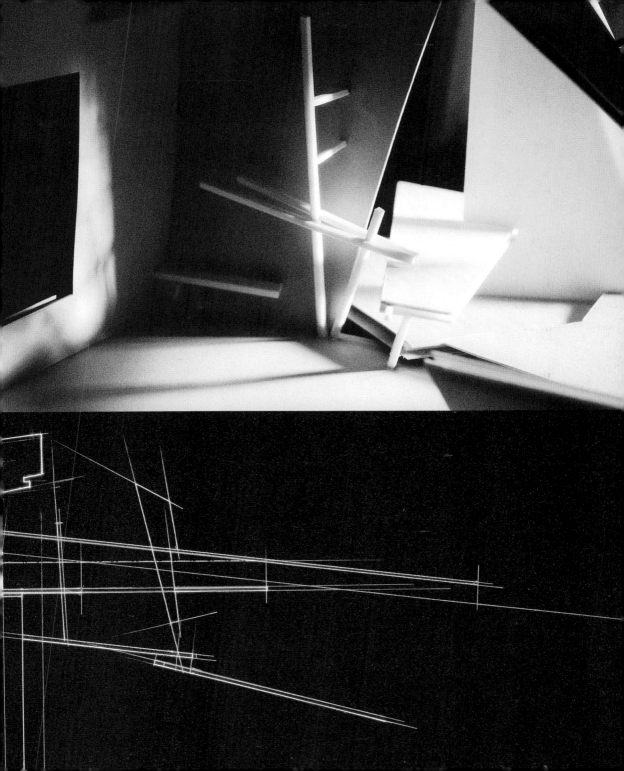

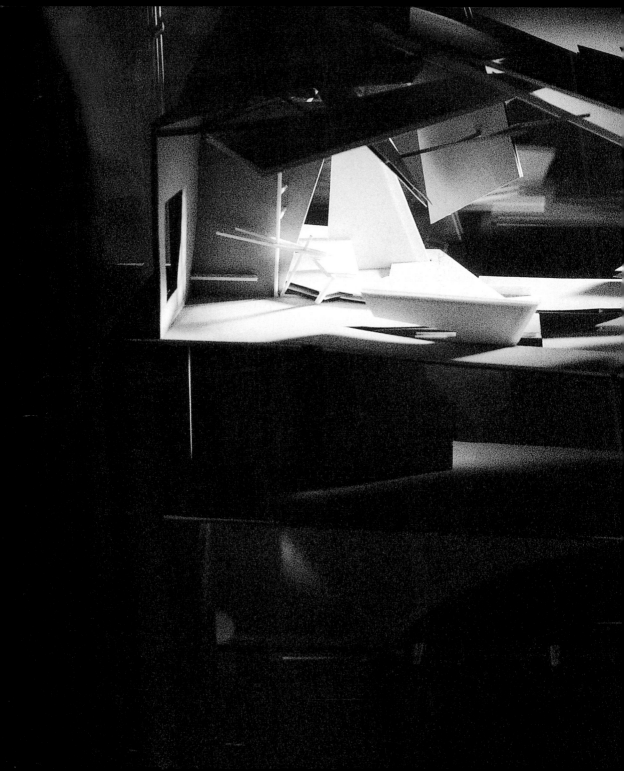

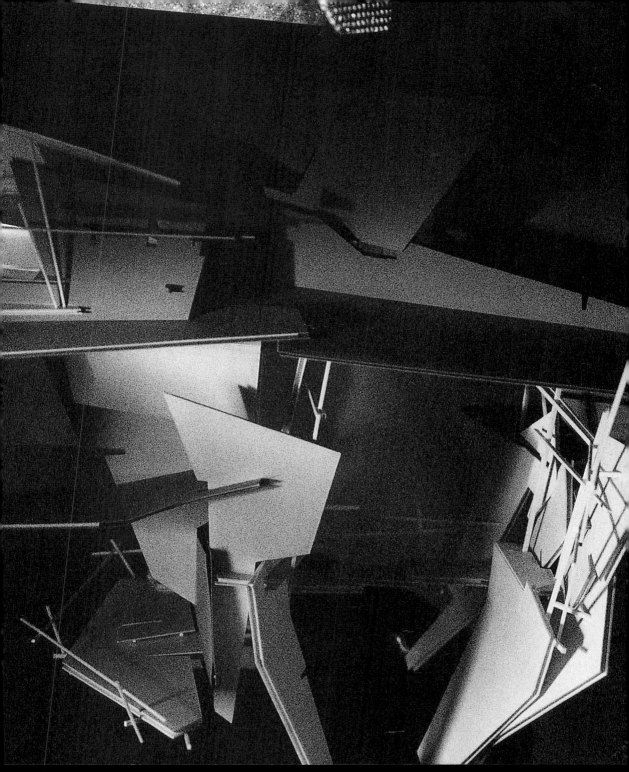

CN°4P38

PRISONER: MECHANICAL-ORGANIC
AGE: UNKNOWN
SEX: YES
CRIME: DISSEMINATION OF HYBRIDS
PREVIOUS CONVICTIONS: NONE

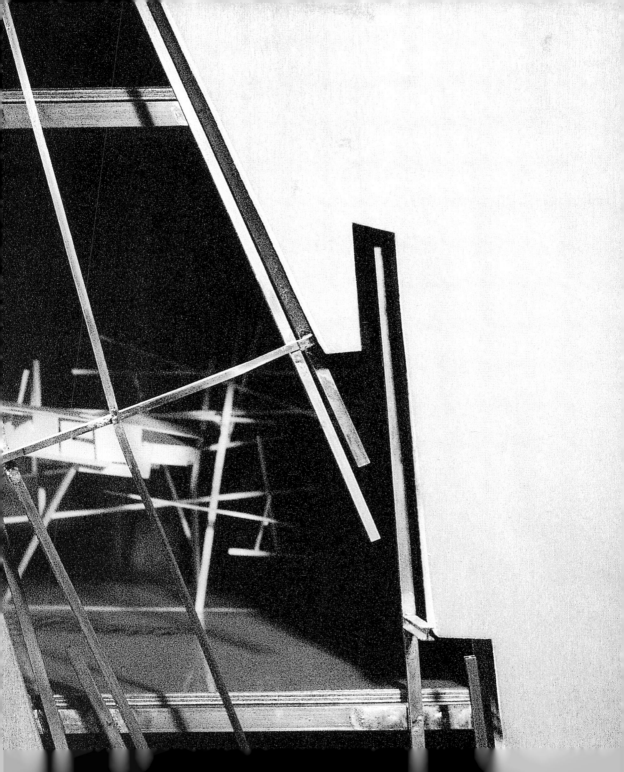

Es geht um eine Architektur, die sich nicht ausschliesslich um Komposition
Verbildlichung von vorgegebenen Funktionen bemüht. Die Identifikation v
existiert als Moment, nicht aber als Konstante....Parkhäuser werden zu Mus
zu Nachtclubs...die Beziehung zwischen Raum und Funktion transformiert
dynamisches Verhältnis..Es existiert keine absolute Wahrheit im architekto
Projekt...Welche Bedeutung es auch haben mag ist eine Frage der Interpreta

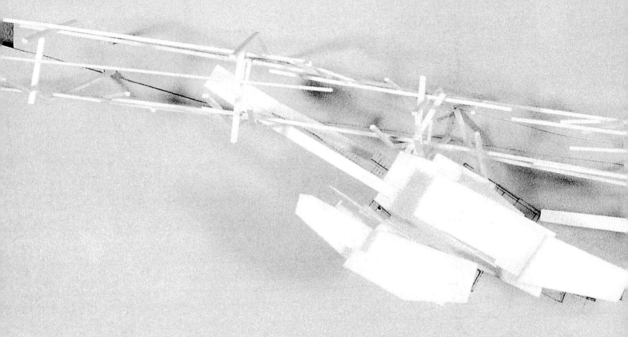

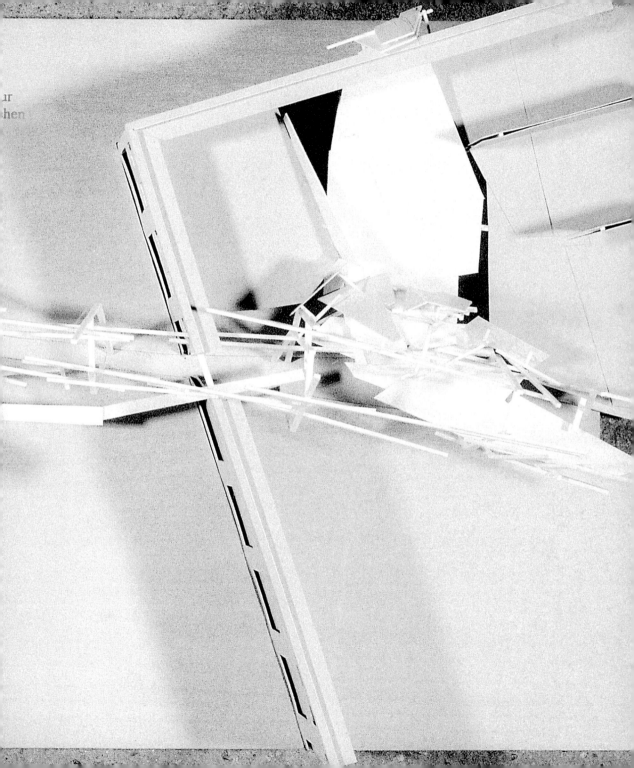

Multifunctionality is what number four is accused of. Basically the accusations are always aimed at the same thing. The charge is that the unambiguous is being dissolved, on trial is the systematic undermining of the uniform system architecture which permits identification. This ultimately goes back to the hierarchical order of the cities of the Antiquity which are the expression of a system of rule. Architecture, as any prestigious building - from the White House in Washington to the new museums - will tell you, is always the expression of a symbolic order, it is not beyond values. That is why the designs of the French architect Boulée are so revolutionary. With his Cenotaph for Newton, he tried create a new symbolic order, albeit based on the Antiquity.

And revolutionary too is the re-use of churches for secular propaganda purposes, converting them, for instance, into swimming pools during the Russian Revolution. But those are still symbolic acts that architecture is illustrating. Part of that is always the anti-symbolic act of destruction or blasphemy, which expresses itself in the iconoclasm of the Reformation, the destruction of the Bastille, the demolition of monuments. Destruction thus replaces transformation. It was not until the new Soviet architecture, the work of architects such as Tatlin or El Lissitzky, that new paths were opened up, approaches that did not use pseudo-ancient symbolism: hierarchies, centres, organisational top and bottom no longer play an integral part.

Thus one could imagine an architecture beyond symbolic orders, a floating, transforming use of symbols. When René Piano, in an interview with the author, compared the contemporary museum to a cathedral, one might think he was talking about a mere displacement of the symbolic level.

But Piano meant something else: he spoke of the multifunctionality of the medieval cathedral, of an everyday symbolism beyond the worship of God. He spoke of how cathedrals had given beggars a roof over their heads, had been places where business was carried out, had been a meeting place for prostitutes and a place of prayer all in one. When his design for the Klee Centre in Berne, Piano takes the idea of a hill, laying himself open to the accusation that he was building a military aircraft hangar, he is simply showing that there can no longer be an unequivocal symbolism for museums, but that the building develops from the use its design has fostered.

That corresponds to museum expert Dieter Bogner comparing the museum to a shopping centre - not just because today's museums have commercial aspects. Bogner is working on the assumption that needs change and that, as a social complex, a museum has to meet those needs. He assumes that each visitor has different needs each time he or she visits. Multifunctionality and flexibility thus belong to the new diffuse symbolism of this institution.

Thus, rethinking the museum means creating a kind of nomadic order, setting up a structure which, modelled on the Internet, constantly provides new links and leads to new home pages that are constantly modified to meet the latest needs. (That is no different from the rhizome, whose original meaning, developed by Deleuze/Guattari, comes from the organic structure of plants). (K.T.)

structure / relations / systems by the interference of network address the situation [-->] it is no longer modernity which ... has undergone a transformation. [21] The task ... of the contemporary world [23] [Taken out of the ... which called _ANESTHETICS_ Forms are not — congestion — superdensity and dense. 2° — 7.2. [27] ... hypothesis and harmony ... more the most of the desintegro — heterogenity, The differences — Urban space cannot processes) ... [dims and path ; not rigidly governed ...) — complexity and chaos [!]] [Refusal of] [29] ... — dynamic / outside — inside coherence — pun / — oximoron ... the [39 / 99 ©] Thin complex of / information ... rich ... oximoron slowly perfectly ... but on overlapping / ... than about also. ... to the already proven — ... before, not ... on — ... on that level. of a lot — ... I don't see ... the — ... much broader ... or whatever round ... **TO OCCUPY** in 2° 7°

We are dealing here with a kind of architecture that is not concerned solely with composition and giving visual expression to prescribed functions. The identification of architecture exists not as a constant but merely as a moment... Multi-storey car parks are turned into museums and churches into night-clubs... the relationship between space and function is being transformed into a dynamic relationship. There is no absolute truth in the architectural project... Whatever meaning it has is open to interpretation.

"The opposition between a mechanical system and an organic system; First of all, a mechanical system is an object in space-time. An organism creates its own space-time by its activities, so it has control over its space-time, which is not the same as external clock time. Secondly, a mechanical system has a stability that belongs to a closed equilibrium, depending on controllers, buffers and buttresses to return the system to set, or fixed points. It works like a non-democratic institution, by a hierarchy of control. An organism, by contrast, has a fluctuation stability, which is attained in open systems far away from equilibrium. It has no bosses, no controllers and no set points. It is radically democratic, everyone participates in making decisions and in working by intercommunication and mutual responsiveness. Finally, a mechanical system is built of isolatable parts, each external and independent of all the others. An organism, however, is an irreducible whole, where parts and whole, global and local are mutually implicated."
Book, Spirals, Quaderns-series, p.151 "The new age of the organicism" by Mae-Wam Ho.

Today, action and reaction occur almost simultaneously... we actually live mythically and integrally, as it were, but we continue to think in the old, fragmented space and time patterns of the pre-electric age...

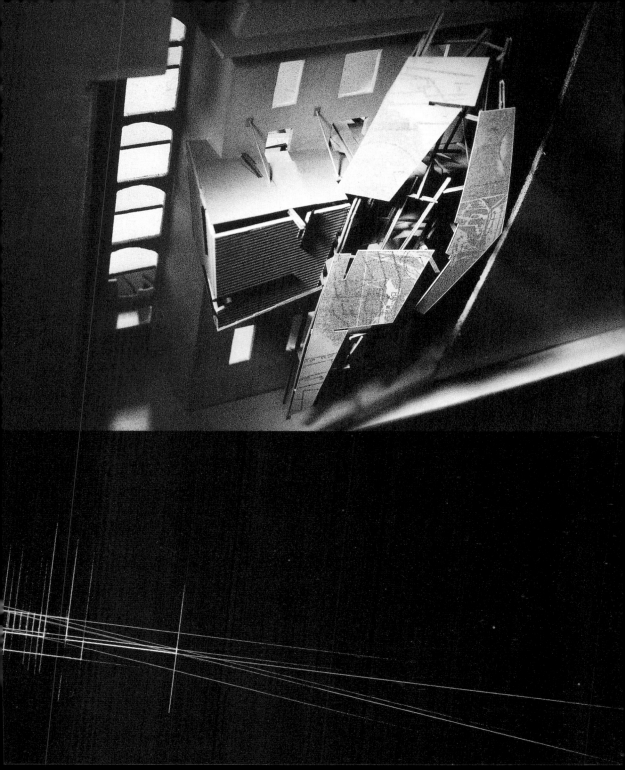

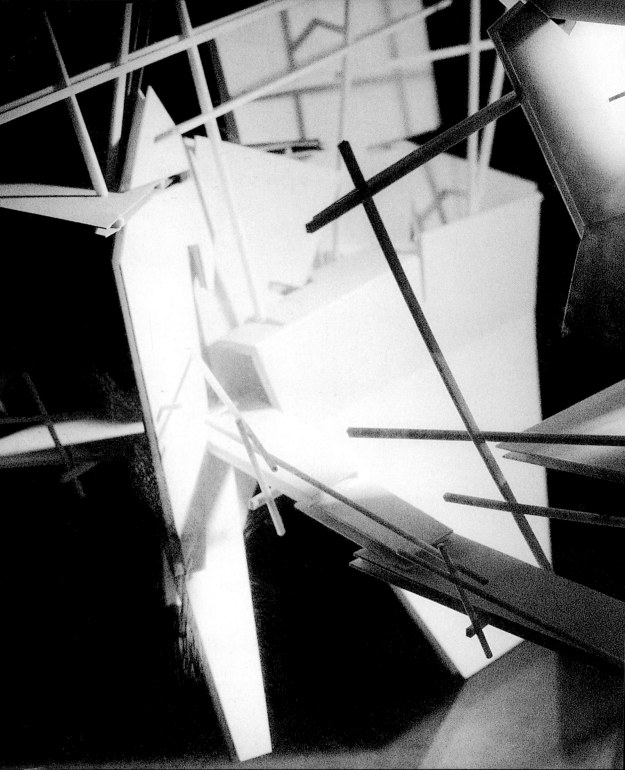

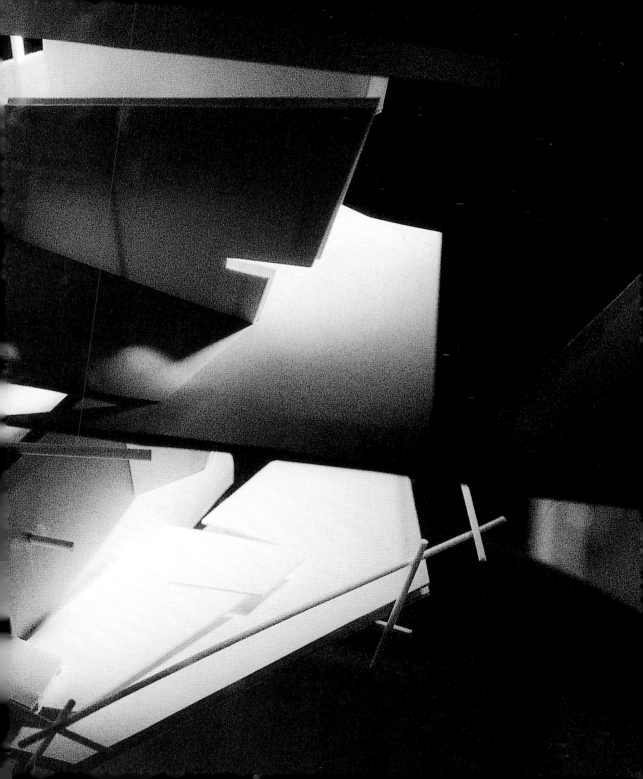

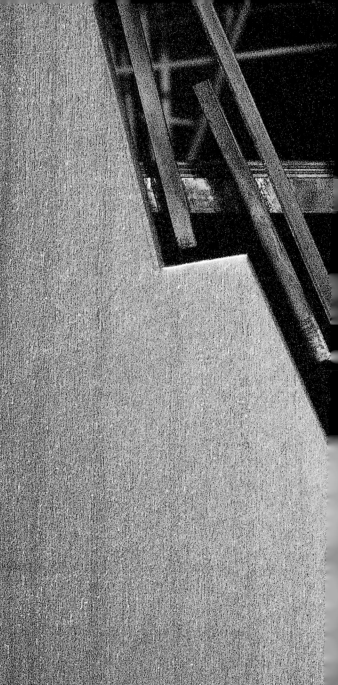

CNºSP48

PRISONER: MOMENTUM OF CONFLICT
AGE: UNKNOWN
SEX: YES
CRIME: ENDANGERING CONTROLLED INSTRUCTION
PREVIOUS CONVICTIONS: NONE

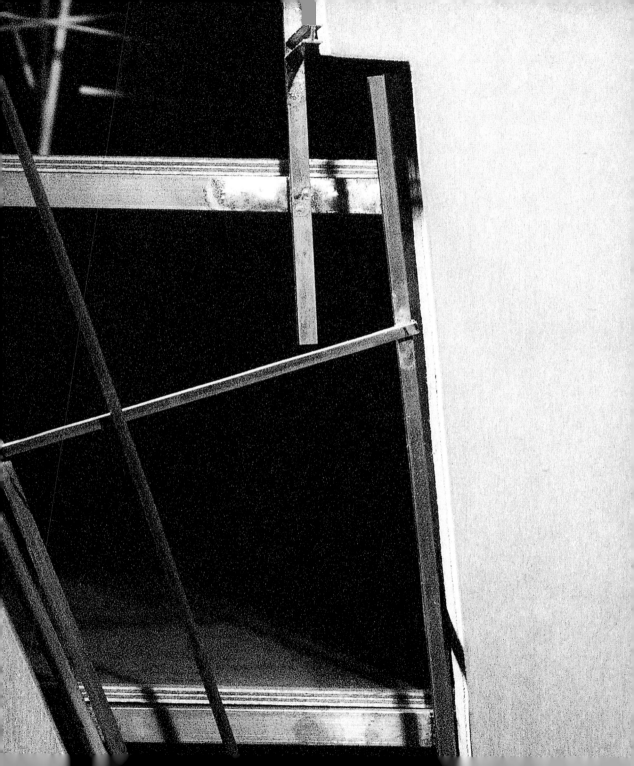

[MEASUREMENT ...] cesium clock has ...

PHASE TRANSITION - Fluid

INTROITUS

ORDER

...nes harmonisches LABYRINTH, von Johann Sebastian Bach...momentaner Verlust der
...ntierung im harmonischen Funktionszusammenhang. INTROITUS.CENTRUM.EXITUS
...itus; erstes räumliches Durchwandern und Bekanntmachung mit den verschiedenen
...nittlungsebenen. Einführung in das Netzwerk der Geschichte.
...rum; Auseinandersetzung in den Kammern oder Teilnahme am Geschehen als Betrachter.
...t in einem zentralen Raum, sondern in dezentralisierten Zentren. Sei es als Handwerker,
...ware-Spezialist, Businessman, Kunststudent...oder Punk.
...viduelle Auseinandersetzungen werden kommuniziert. Die Informationszusammenhänge
...immer verschieden...wandelnde Identität. Auseinandersetzung mit dem Moment, im
...text und unter Einfluss der Historie...
...sche: „Historie...Das Uebermass an Historie hat die plastische Kraft des Lebens
...egriffen, es versteht nicht mehr, sich der Vergangenheit wie eine kräftige Nahrung zu
...enen."
...sche: „Miss nur einmal deine Höhe als Wissender an deiner Tiefe als Könnender."

Kleines harmonisches **Labyrinth** - Johann Sebastian Bach
harmonischen Funktions zusammenhang - INTROITUS . LENT
"Bekanntmachung" der Vermittlungs stationen - Einführung in
in den Hörnern oder als Betrachter - nicht in einem Beute
als Handwerker, sofware spezialist od Kunststudent .. od
kommuniziert. Auf zusammenhänge sind immer verschied
moment [MEASUREMENT ; a coesium clock has, since
of the Duration of 9'192'631'770 cycles of atom
od the distance that light travels through a vacu
von Kultur - in einem dynamischen System.. ORDER
Matter ; solid - PHASE TRANSITION - Fluid -
durch Hitze, energy or information - Konflikt der Zu
Griechen: - chaos organisieren - [p. 109] - Historie nebst
das Frühere teils als Vorbild zu wiederholen, teils treu zu
willen zu zerbrechen, [p 103] Das übernotes on HISTORIE
Lebens angegriffen, er versteht nicht mehr, sich der Vo
Zu bedienen - [p. 92] Die Massen scheinen nur nur in dre
dienen ; [1] schwimmende Kopie der Grossen Männer, [2] wie
Zeuge der Grossen ; Statistik.. Gesetze ; Geschichte [p

And the best aesthetic harmony develops through conflict, tension, resistance. That is ultimately the lesson that all s
accused have to be taught. Whoever defends the others who are on trial also defends the fifth. (That is the only continui
in this argumentative discontinuum.) (K.T.)

Geschichte ihre Bedeutung nicht in den ewig. geds
erkennen durfte. sondern dass der Wert gerade des ist

...tz — momentaner höhst der Orientierung im

EXITUS. [Introitus]; 1stes röml. Durchwandort (-und
noch der Geschichte) [CENTRUM]: Auseinandersetzung
...um, sondern in Dezentralisierten Zentren. Sei es
[EXITUS]; individuelle Auseinandersetzungen werden
...ndelne Identität. Auseinandersetzung mit dem —
...redefined the botic measure of the SECOND
...iction, since 1983. the METER has been redefined —
i.e, as $1/299'792'458$ of a second - messung -
...LEXITY - CHAOS. It is about on edge-condition
...systeme vom "Gleichgewicht" entfernt worden
...change and business of usual - Nietzsche - [p.107:]
...teil such Nutzen, Bedürfnis;
...teils an künftiges Werden —
...die plastische Kraft des
...heit wie eine kräftige Nahrung
...hinsicht einen Blick zu vor-
...gegen die grossen [3] Woh-
..."Miss nur einmal deine
...Wenn der Not einer Droma,
..."so wurde der Droma selbst ein
...und so hoffe ich, dass die
...als eine der Blüte und Frucht,
...bekommter villeint man ...tag...

rmonious LABYRINTH, by Johann Sebastian Bach... momentary loss of orientation
harmonious connection between functions.
NTROITUS.CENTRUM.EXITUS
ntroitus; initial experimentation and familiarisation with the different levels of
ommunication. Introduction to the network of history.
entrum; study in the carrels or participation as an observer in current events.
ot in a central space but in "decentralised centres." Whether as a craftsman, software
pecialist, businessman, art student, homeless person or punk...
xitus; individual examples of intellectual engagement are communicated. The context of
piece of information is always different... changing identity. An engagement with
he moment, in context and under the influence of history...

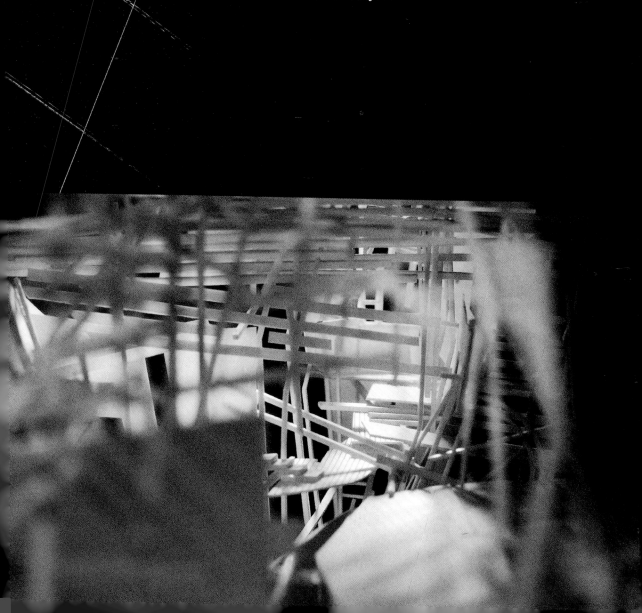

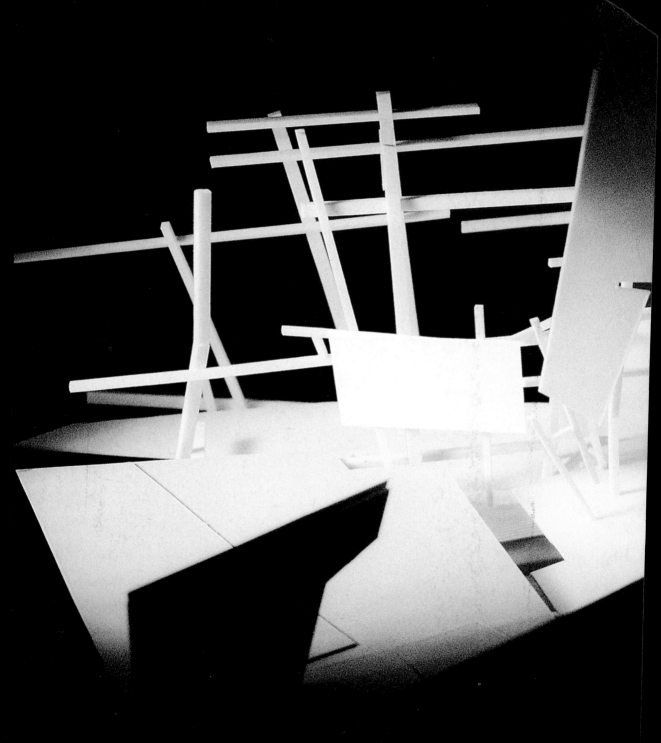

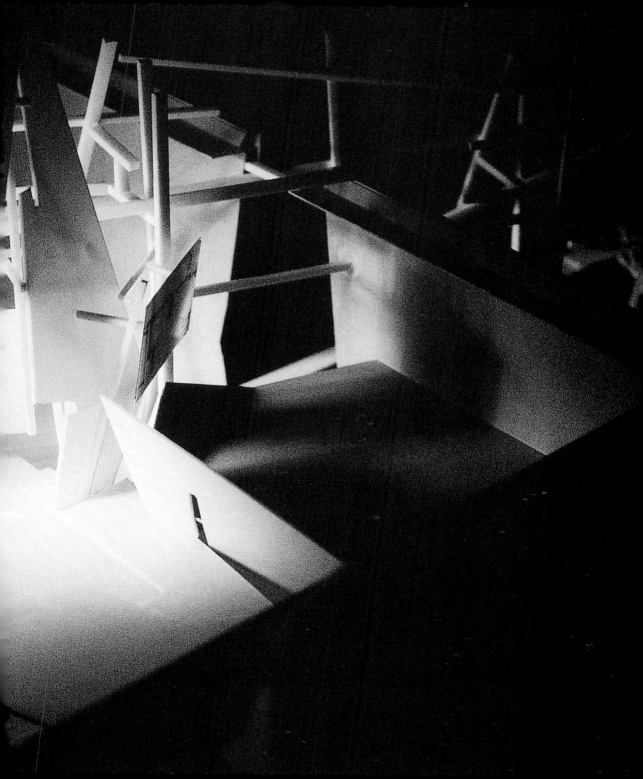

CN°6P58

PRISONER: NO COLLISION... NO SPACE
AGE: UNKNOWN
SEX: YES
CRIME: TRANSFORMATION OF DISTURBANCES AND
CONFLICTS INTO NEW STRUCTURES, DESCRIBED
AS COMPLEX, WHICH UNDERMINE THE SYSTEM
PREVIOUS CONVICTIONS: NONE

Da die Anzahl der beteiligten Elemente am „Geschehen" : .g zunimmt, sei es
in der Architektur, in der Politik und im Leben als solches, ist es offensichtlich,
Gefüge von einer simplen Behauptung in etwas mehr komplexeres übergehen m
beschreibt eine Ueberlagerung von Vorhersehbarkeit und Experiment. Das vorg
Konzept strebt eine höhere Organisation aus Ordnung und Chaos an.
Die alten Bedingungen linearer Perspektive mit Fluchtpunkt und Horizontlinie v
hinter uns in dem Moment, wo das moderne urbane Leben vielfache Horizonte s
Fluchtpunkte erscheinen lässt, exzentrisch, fraktal, dekonstruiert, unangepasst. E
Formationen, an welche neue Räume und Elemente ohne Opferung des Ganzen
werden können, gerade weil es kein Ganzes, keine Totalität gibt. Es umschreibt
Komplexität, innerhalb welcher sich temporäre Informationszusammenhänge bi
Eigenständige, charaktervolle Strukturen entstehen, welche nur besetzt werden k
auch eine starke, individuelle Idee vorhanden ist.

Da die Anzahl der beteiligten Elemente am "Geschehnis" &
Politik od des Leben zu ziels, ist es offensichtlich, dass
Behauptung in etwas mehr KOMPLEXERES übergehen muss
von vorhersehbarkeit und experiment. Gut und schlecht
heiß und Kitsch ... are really "out there" and "in here". [1]
= natural languages [T₁ +.7 .+, 0.27] und. + 27 [2] Representation of
truth . - SELF · ORGANISATION [3] ORGANISATIONAL DEATH .
ist nicht "New age"; verbinde, verbinde immer alle) untere
traditionell ; "order the chaos" [---] aber : höhere Organisa
chaos [!] [5:] celebration of DIVERSITY . [6] Include the
In architecture - the new metaphysics calls for mo
than repetive squares. architecture might reflect the
its energy, its growth and sudden leaps, its be
system problem aufeinander und entwickelt, ling in
Wandel permanenter auseinandersetzung befindet . durch
für uns [2 ⊕ -7 . app .1935 . 25ᵗʰ] . gibt es immer ob
entsteht . EPOCHENRÄUME ; sie kommen anstoide der

Rethinking the museum. Just that. Is that so dangerous? Knowing that the parallel lines, which have determined archi-
tectural space and how we perceive it since the Renaissance, are also just a construct, and are in turn based on the
construct of a single, central, divine subject. In the contemporary museum, the Muses, you need to know, also embr
the contemporary, multi-identity, absolutely un-divine subject of the present. (K.T.)

und schließlich eine des tisch ablaufs im "museum
Konfrontation mit dem Netz - bestimmen das ges
Abfolgen der Kunst. Giedeon — Es ist nicht fein d

· EPOCHENRAUM · Nr 3 ⊕ 1735·25 ·

Left margin (partial):
```
uuuut ,
getuge
uhrinbt
und uch
 my slore
esfiel –
rity –
.. und
J [5·7·0 ⊕]
EMPORARY
Stimously
SSES of
( twirb
dlos
vom un
my dem
le )
```

Right margin:
```
ob Kunst, doch,
von einer einzlen
eine Ideologisirung
wacht; schön –
to NATURE and
COSMOGENETIC
DOS getuge [4]
aber nicht –
ordnung UND ⊕
· SCIENCE ·
changing shapes
the universe
curls and turns,
das doch im ein-
ausinnandrehen
eine Summenpolei
```

Bottom:
der Geschichte ; dieses Aufumodspollen bewirkt
aufig au Kriegen, Katastrophen, pol. Ereignisse
schreiben die Dynamik der Auseinandersetzung ,
Meerplatzen der Geschichte sowie die Strukturelle
. Auditorien oder Foruns bilden die Volumwirthen
um. Dessen und immer treten mir auf, – Equ.

The epoch spaces only exist as a result of the disturbance between the epochs; it is they that create the space.

As the number of elements participating in current events is constantly increasing, whether in art, architecture, politics and life itself, it is obvious that the structure has to change from a simple statement of fact into something more complex. It describes an overlap between predictability and experiment. The proposed concept is aiming for a higher organisational form founded on order and chaos.

The conditions of linear perspectives with vanishing point and horizon line disappear the moment modern urban life lets multiple horizons and vanishing points appear: eccentric, fractal, deconstructed, unadapted. Formations emerge to which new spaces and elements can be attached without sacrificing the whole, exactly because there is no whole, no totality. It circumscribes a complexity within which temporary connections between pieces of information are formed. Autonomous, character-rich structures are formed, but they can only be occupied if a strong individual idea also exists.

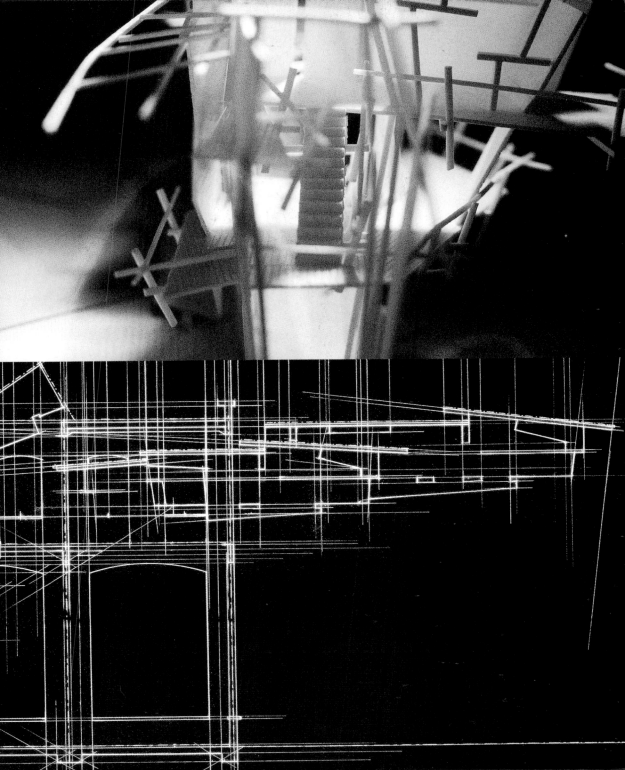

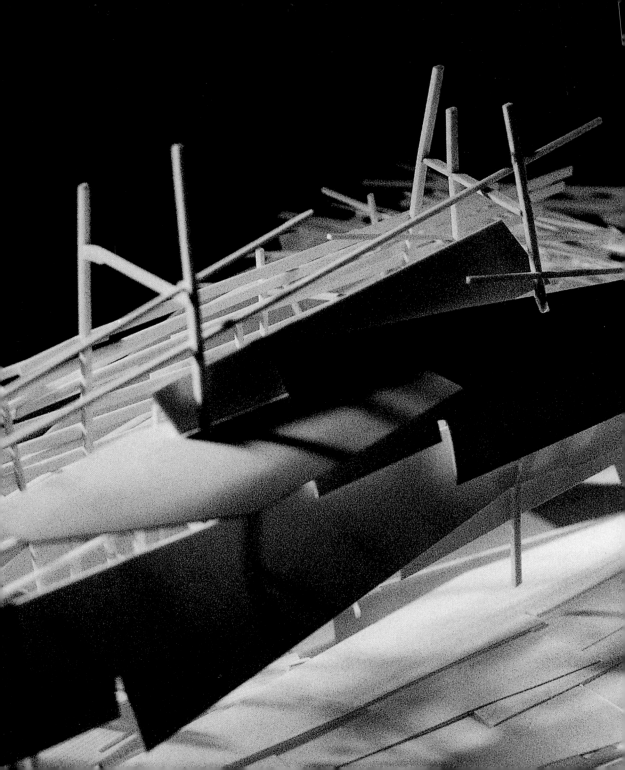

GUY LAFRANCHI

Born 1966 in Bern, Switzerland. Educated in Architecture at the ETH-Zürich, Diploma under Professor Flora Ruchat, 1994. Worked on several projects in collaboration with the Atelier Ueli Schweizer, Bern; designed the sai-project Luzern, in collaboration with RFR engineers in Paris (founded by Peter Rice). Since 1995 in private practice. Realization of the project Villa Alpenstrasse 27, Bern, 1995. Collaboration with Lebbeus Woods since 1995. Worked on the Tank Project, Bern, 1995-6. Associate Director of RIEAeuropa since 1997. Co-founder of RIEAeuropa.ch, Bern, Switzerland. Realization of the project Erweiterung Landhaus Waldegg, Zollikofen, Switzerland, 1998. Has lectured on his work at the Bartlett School of Architecture, London, The Netherlands Architecture Institute (NAI), Rotterdam, the BorderLine Workshop, Kraljevica, Croatia, SCI-Arc: Vico, Vico Morcote, Switzerland. He is currently Associate Academic Director of the RIEAvico School of Architecture in Vico Morcote, and lives and works in Bern.